Dedicated to: All artists everywhere, creating.

The War of Art is a direct interpretation of Sun Tzu's, The *Art of War* as it correlates to artists and other creative.

WRITTEN BY

THE URBAN MONK

Chapter One:

Creating the Plan

C.1

1. The Urban Monk states: *The War of Art* is of vital importance to civilization, in both reflecting upon the past & looking ahead to the future, but especially in the essence of now.

2. Art is life. Art is death. Art is a road to enlightenment and ruin, but never safety. Art is a subject of over intellectualized cannibalism, despite these short comings it must be pursued to dire consequences and on no account be neglected.

3. *The Art of War*, then, is contained within five unconditional truths, to be held in thought during creation of the plan, when researching the conditions obtained in the field.

4. The five Unconditional Truths: (1) The Moral Law; (2) Heaven; (3) Earth; (4) The Artist;

C.1.(1-4)

5,6. The MORAL LAW causes to be complete accord with the current of creation. One must

5-6*(cont'd)*. follow this current regardless of one's life, undeterred by any danger. (regardless of social, economical, political, cultural, self manifested, or mentally).

7. HEAVEN signifies night and day, cold and heat, times and seasons. The elements and conditions of an artist's past, current, and future passion atmospheres.

8. EARTH comprises distance, great and small; danger and security; open art ground and narrow passes, both physical and mental. The chances of Life, Death, Success, and Failure.

9. The ARTIST embodies the sacred beliefs of integrity that keep an artist true to one's self and the art they represent. Through benevolence, wisdom, sincerity, courage, and strictness that

9. *(cont'd).* these virtues remain uncontested.

10. By METHOD & DISCIPLINE are to be understood as the self marshaling of an artist in their proper subdivision. The mastery of techniques amongst an artist's craft, the patron, client, friend, family, community, or any other audience may experience an artist's work. Along with accountability and control over artistic expenditures.

11. These five currents of energy should course through every element of an artist's being. One who masters them will be successful one who chooses a short and quickened path will fail.

12. Therefore, in deliberations of current, when seeking to determine the artistic condition, let

12 *(cont'd),* them be made in the fundamentals o comparison, in this way:

13(1). Which of the artistic decisions is imbued with Moral Law?

13(2). Which choices push the artistic mode towards further betterment?

13(3). In which choice does the burden of advantage way heavier on the shoulders of one derived from Heaven and Earth.

13(4). Which choice is discipline and control of current most rigorously embraced?

13(5). Which technique is strongest and deemed most appropriate for undertaking?

13(6). Of which choices an audience is most adept and receptive to. (the most receptive and adept is not the truest, one must educate one's audience, even when facing hostile responses.

13(7). In which exhibition is there the greater consistency both in reward and failure.

<center>C.1.(13)</center>

14. By answering these seven elements of consideration. One can forecast success or failure.

15. The artist that applies this counsel and acts upon it, will succeed: - Let such a one command the audience of their work! The artist that ignores this counsel neither applying or acting upon it, will suffer failure: - let such an artist be left to their own demise.

16. While benefitting from the application of these lessons, philosophies, and guidelines of counsel, listen with open ears to those experiences that deem helpful from circumstances of one's self and other artists over and beyond the ordinary rules.

17. When circumstances are within one's favor, one should modify their plan accordingly.

C.1.(14-17)

18. All art, like warfare, is based on deception. (it's essence is to deceive the audience into emitting emotion from which in all accords is emotionless. It is the artist that creates the emotion that which then must be conveyed through the art.)

19. In application, when able to exhibit, it best appear passive; when using heavy technique, one must seem without method; when the audience is near, make the audience distant. When distant, make them believe it is their emotion the work embodies.

20. Bait the audience to entice them. Feign disorder, and crush the audience.

21. If the audience is secure at all points, be prepared for them. The artist is in superior strength of work, invade them.

22. If the audience is chloric temper, seek to irritate.

23. If the audience is relaxed engage.

24. Attack the audience where they are unprepared, appear where artists are not expected.

25. These aggressive devices, lead to success, must not be divulged beforehand.

26. The artist who succeeds in an exhibition makes many calculations in one's temple (studio). This is where the exhibition's true success or ultimate failures lay.

CONCLUSION:

The artist who loses an exhibition makes but few calculations before. With many calculations leads to success, and few calculations to failure: With no preparation failure is inevitable. It is with strict attention to this detail that an artist can foresee their own success and failure.

Chapter Two

WAGING

ART

c. 2.

1. In the operations of art, where there are in the field a thousand small works, as many heavy works, and a hundred thousand prints, with provisions to carry them a thousand miles, the expenditure at home and at the front, including entertainment of guests, small items as brushes and paint, and sums spent on transport and insurance, will reach the total of a thousand ounces of silver per day. Such is the cost of raising an army of art 100,000 works in total.

2. When one engages in actual art, if success is long in coming, then an artist's weapons will grow dull and their techniques watered down. If any one lay siege to a town, an artist will exhaust their strength and command over an audience.

3. Again, if the exhibition is protracted, the success of the artist will not be equal to the strain.

4. Now, when an artist's weapons dull, materials

4*(cont'd)*. watered down, strength exhausted and treasure spent, other artists will spring up to take advantage of your extremities. Then no one, however wise, will be able to avert the failures that ensue as a result of these consequences.

5. The stupidity of haste in art cannot be marginalized, but inventive cleverness has never been associated with long delays.

6. There is no instance of a country having benefitted from prolonged warfare against art.

7. It is only one who is thoroughly acquainted with the evils of the art world that can thoroughly understand the profitable way of carrying on art.

8. The skillful artist does not raise mistakes, neither are one's supplies loaded more than twice

8*(cont'd)*. An artist improvises making learning experiences out of mistakes and if one is skillful enough absorbs the negative connotation designated to mistake, into the positive connotation of an applied, new technique.

9. Bring art supplies with everywhere, but adapt to what is found in the community. Thus,, an artist will always have material to work with and never want for more than is available. If necessary let these materials dictate the technique and go with the current.

10. Poverty of the audience causes an artist to be maintained by contributions from a distance.

11. On the other hand, the successful self-sufficiency of an artist causes prices to go up; and high prices cause common, communal alienation and the people's substance to be drained.

C.2.(8-11)

12. When the community's substance is drained away, the peasantry will be afflicted by heavy exactions with negative consequences to the artist.

13,14. With the loss of substance and exhaustion of spirit, the homes of people will be stripped bare, and three-tenths of their income will be dissipated; while the government expenses can assume be allocated for defense, education, infrastructure, and other aspects of the community deemed more warranted for the people's taxes,

15. Hence, a wise artist makes a point of assimilating with the community. One cartload of the community's provisions is equivalent to twenty of one's own, and likewise a single month of one's provender is equivalent to twenty from one's own studio.

C.2.(12-15)

16. Now in order to succeed against nay-sayers, artists must be roused to anger; that there may be advantage from success in the face of doubters, an artist Must find reward after each achievement whether it be financial, enlightenment of technique, or personal fulfillment. (notice: social reward is not designated as art for ego's sake which will hinder an artist's progress.)

17. Therefore in the establishment of Artist's territories, those walls which prominently exhibit one's work, along with the fairest treatment of the artist should be rewarded with the signature pieces. Also take into account the audience and its volume. One's own flags should be intermingled with those of the venue, and the propaganda mingled and used in conjunction with theirs. These captured walls should be kindly treated and kept, with frequent interactions to the merchant owners of said walls.

C.2.(16-17)

18. This is called using the conquered venue to augment one's own strength.

19. In art, then, let one's great object be success, not lengthy campaigns.

20. Thus it may be known that the artist is the arbiter of the people's fate, the one on whom it depends whether society shall be in peace or in peril. (Which such emphasis on the outcome an artist should put great stock in their work and its' value!)

CHAPTER THREE

STRATEGIES
of an
ART ATTACK

C.3

1. In the practical *War of Art*, the best thing of all is to take the art world whole and intact; to shatter and destroy it is not so good. So, too, it is better to recapture an entire wall than to destroy it, to capture a venue, or a company entire than to destroy it.

2. Hence to exhibit art and conquer in all one's exhibitions is not supreme excellence; supreme excellence consists in breaking the audience's resistance without alienation, but conflict may still arise.

3. The highest form of artistic generalship is to balk the audience's plan; the next is to prevent the interference of negative audience forces; the next in order is to engage the audience in the field; and the worst of all is to ignore walled cities.

4. The rule is, not to ignore walled cities of art if it can possibly be avoided. The preparations of mantlets, movable shelters, and various implements of art, will take up to three whole months; and the piling up of art over against the walls will take three more months.

5. The artist, unable to control one's irritation, will launch art to exhibition like swarming ants, with the result that one-third will not be sold, while the town still remain untaken. Such are the disastrous effects of ignorance.

6. Therefore the skillful artist subdues the audience without any fighting; capturing cities without oversaturating the market; overthrowing the art world's kingdom without any lengthy exhibitions in the field.

7. With art intact, the artist will dispute the mastery of the art world, and thus, without fail,

7*(cont'd)*. triumph will succeed/ This is the method of an art attack.

8. It is the rule in the *War of Art*, if art is ten to the audience's one, to surround them; if five to one, to attack: if twice as numerous, to divide the art in two exhibitions.

9. If equally matched. An artist offers exhibition; if slightly inferior in numbers, one can avoid the audience; if quite unequal in every way, an artist must retreat to produce more work. With each exhibition, one must be fully prepared for all can rise and fall with just one exhibition.

10. Hence, an artist may impact an audience of superior intellect with lesser refined work, but a consequence is having all future work conditioned to the same sub par standard. Unless exposing the truth of the artist's original integrity

10(cont'd). demising the level.

11. Now, the artist is the bulwark of the Art World; If the bulwark is complete on all points; the Art World will be strong; if the bulwark is defective, the Art World will be weak.

12. There are three ways in which an artist can bring misfortune upon one's work.

13(1). By inspiring the audience to advance or retreat, being ignorant of the fact that it cannot obey. This is called hobbling the audience.

14(2). By attempting to govern an audience in the same way as one administers a kingdom, being ignorant of the conditions which obtain in an audience. This causes restlessness in the patron's minds.

<div align="center">C3.(10-14.2)</div>

15(3). By employing family of one's audience without discrimination, through ignorance of artistic principle of adaptation to circumstances. This shakes the confidence of the patrons.

16. But when the audience is restless and distrustful, trouble is sure to come from other feudal critics. This is simply bringing anarchy into the audience, and flinging success away.

17. Thus, one may know that there are five essentials for success:

(1) One will succeed who knows when to exhibit and when not to exhibit.

(2) One will be successful whose audience knows how to handle both superior and inferior audiences.

(3) One will be successful whose audience is animated by the same spirit throughout ranks.

C.3(14.3- 17.3)

17(4). One will succeed who; prepared one's self, waits to take the audience unprepared.

17(5). One will succeed who creative and artistic capacity and is not interfered with by the art world.

18. Hence the saying: If you know the audience and know yourself, you need not fear the result of a hundred exhibitions. If you know yourself but not the audience, for every success gained you will also suffer a great failure. If you know neither the audience nor yourself, you will succumb in every exhibition.

Chapter Four
Tactical Artists of Success

C.4

1. The great artists of old first put themselves beyond the possibility of failure, and then produced while at attention for an opportunity of success in front of an audience.

2. To secure one's self against failure lies in one's own hands, but the opportunity of success through the audience is provided by the audience itself.

3. Thus the great artist is able to secure one's self against failure, but cannot make certain of conquering success.

4. Hence the saying: One may KNOW how to succeed without being able to do it.

5. Security against failure implies of defensive tactics; ability to succeed in the face of the

5(cont'd). audience means taking the offensive.

6. Standing on the defensive indicates insufficient artwork; attacking, a super abundance of artwork.

7. The artist who is skilled in techniques hides in the most secret recesses of earth; one who is skilled in production flashes forth from the topmost heights of heaven. Thus, on the other hand one has the ability to protect our techniques in secrecy; on the other, a success that is complete.

8. To see success only when it is within the opinion of the audience is not the acme of excellence.

9. Neither is it the achievement of excellence if

9.*(cont'd).* the whole Art World says," Well done!)"

10. *To lift an autumn hair is not sign of great strength; to see the sun and moon is no sign of sharp sight; to hear the noise of thunder is no sign of a quick ear."* - Sun Tzu, *Art of War*

11. What ancients called a clever artist is one who not only succeeds, but excels in succeeding with ease.

12. Hence one's success brings them neither reputation for wisdom nor credit for courage.

13. An artist succeeds in art by making mistakes. Making mistakes is what establishes the certainty of success, for it means conquering a piece that was already a failure.

C.4(9-13)

14. Hence the skillful fighter puts one's self into a position which makes failure impossible, and does not miss the moment for inspiring an audience.

15. Thus, it is successful artist strategist only seeks exhibition after the venue has been successful, whereas one who is defined by their art and afterwards looks for success.

16. The consummate artist cultivates moral law, and strictly adheres to method and discipline: thus it is in one's power to control success.

17. In respect of artistic method, one must, firstly, Measurement; secondly, estimation of quantity; thirdly, calculation of color; fourthly, balancing of chances of failure; fifthly, success.

18. Measurement owes its existence to Earth; Estimation of quantity; Balancing of Production to Calculation; and success to Balancing of Failures.

19. A successful artist opposed to a routed one, is as a pound's weight placed in the scale of a single grain.

20. The onrush of a conquering exhibition is like the bursting of pent-up waters into a chasm a thousand fathoms deep.

CHAPTER FIVE

ENERGY

Ch. 5

1. The control of a large body of work is the same principle as the control of a few; it is merely a question of dividing up the numbers.

2. Exhibiting with a large body of work within one's arsenal is no way different from exhibiting with a small one: it is merely a question of instituting signs and signals within the exhibit.

3. To ensure that one's whole body of work may withstand the brunt of the audience's critiques and remain unshaken- this is effected by maneuvers direct and indirect.

4. That the impact of one's artwork may be like a grindstone dashed against an egg- this is effected by the science of weak points and strong.

5. In all scenarios, the direct method may be used for exhibition, but indirect methods will be needed in order to secure success.

6. Indirect exhibitions, efficiently applied, are inexhaustible as Heaven and Earth, unending as the flow of rivers and streams; like the sun and the moon, they end but to begin anew; like the four seasons, they pass away to return once more.

7. *"There are not more than five musical notes, yet the combinations of these five give rise to more melodies than can ever be heard."* - Sun Tzu, *The Art of War*

8. *"There are not more than five primary colors (blue, yellow. red, black, and white), yet in combination they produce more hues than can ever been seen."* - Sun Tzu, *The Art of War*

10. In exhibition, there are not more than two methods of attack- the direct and the indirect; yet these two in combination gives rise to an endless series of exhibitions.

11. The two paths consist of but one line. Circular by design both remain interwoven as the same. Neither ends, nor begins in relation to one another.

12. The onset of art is like the rush of a torrent which will even roll stones along its course.

13. The magical quality of a genuinely unique technique is like the well-timed swoop of a falcon which enables it to strike and awe-inspire the audience.

14. Therefore the good artist will be terrible

14*(cont'd).* in one's onset, and prompt in the decision.

15. Energy may be likened to the bending of a crossbow: idea, materials, decision, to the release of the trigger.

16. Amid the turmoil and tumult of an exhibition, there may be seeming disorder and yet no real disorder at all; amid confusion and chaos, one's array may be without head or tail, yet it will be proof against failure.

17. Disorder postulates perfect discipline, fear postulates courage; weakness postulates strength.

18. *"Hiding order beneath the cloak of disorder is simply a question of subdivision; Concealing courage under a show of timidity presupposes a*

18*(cont'd). fund of latent energy; masking strength with weakness is to be effected by tactical disposition."* - Sun Tzu, *The Art of War*

19. Thus, an artist who is skillful at keeping the audience on the move maintains engaging appearances, according to which the audience will act. One sacrifices something that the audiences snatch at it.

20. By holding out bait, the artist keeps the audience eager on march; then with a body of selected work one lies in wait for exhibit.

21. The clever artist looks to the effect of combined energy, and does not require too much from the audience. Hence one's ability to pick out the right materials and techniques thus utilizing combined energy.

<center>C.5.(18-21)</center>

22. When an artist uses combined energy, the art becomes as it were unto rolling logs or stones. For it is the nature of a log or stone to remain motionless on the ground, and to move when on a slope: if four cornered, to come to a stand still, but if round shaped, to go rolling down.

23. Thus, the energy developed by a great artist is as the momentum of a round stone rolled down a mountain thousands of feet in height. So much on the subject of energy.

CHAPTER SIX

weak WALLS,

&

STRONG ARTISTS

C. 6.

1. Whoever is first on the walls and awaits the coming of the audience, will be fresh for exhibition; whoever is second in the Art World and has to hasten to exhibit will arrive exhausted.

2. Therefore the clever artist imposes one's art on the audience, but does not allow the audience's will to be imposed on one's work.

3. By offering out advantages to the audience, one can cause the Art World to approach of their own accord; or, by inflicting secrecy, one can make it impossible for the art world to draw near.

4. If the audience is taking their ease, an artist can harass them; if well supplied with intellect, dumb them down; if quietly encamped, one can force the audience to move.

<div style="text-align: center;">C.6(1-4)</div>

5. Appear at venues which the audience hastens to attend; march swiftly to places where an artist is not expected.

6. An artist may march great distances without distress, if one marches through country where the Art World is not.

7. An artist can be sure of success in exhibition if only attacking places which are undefended. One can ensure the safety of their work if only holding positions that cannot be attacked.

8. Hence that artist is skillful in attack whose audience does not know what to defend: and also is skillful in defense whose audience does not know what to attack.

9. O divine art of subtlety and secrecy! Through

9*(cont'd)*. you one learns to be visible, through you in audible; and hence an artist can hold the audience's attention in our hands.

10. An artist must advance, conquer, and be absolutely irresistible, if one is to make for the audience's weak points; one may retire and be safe from pursuit if one's movements are more rapid than those of the audience.

11. If an artist wish to provoke an exhibition, the audience can be forced to engagement even though they are sheltered behind a high rampart and a deep ditch. All an artist need do is attack some other place that they will be obliged to attend.

12. If an artist does not wish to exhibit, one can prevent the audience from engaging even though

12(cont'd). the lines of one's studio be merely traced out on the ground. All one need do is to throw something odd and unaccountable in their way.

13. By discovering the audience's disposition and remaining invisible, an artist can keep art concentrated, then the audience must be divided.

14. An artist must form a single united body, while the audience must split up into fractions. Hence there will be a whole pitted against separate parts of a whole, which means that an artist's body of work will be united in the many to the audience's few.

15. And if an artist is able to exhibit at an inferior venue with superior art, the audience will be in dire awe.

<center>C.6.(12-15)</center>

16. The spot where artists intend to exhibit must be known when everything is aligned; for then the audience will have time to prepare for a possible exhibit at specified venue; And the audience being thus will not be mentally exhausted even before the start.

17. For should the audience strengthen their front, they will weaken their rear; should the audience strengthen their rear, their facade will weaken; should they strengthen then their left, their right will weaken if the audience sends for reinforcements everywhere, they will be weak everywhere and success id eminent.

18. Numerical strength comes from having to prepare for possible exhibitions; numerical weakness, from compelling critical adversaries in the Art World who make preparations against artists.

<div style="text-align: center;">C.6.(16-18)</div>

19. Knowing the place and time of the upcoming exhibit, an artist may concentrate from the greatest distances in order to create allowing for work, soul, and mind state achieve a total preparation of presentation

20. But if neither time nor place be known, then failure is imminent.

21. According to my estimate ninety-five percent of other artists do not exceed than that of my own in numbers, that shall advantage them nothing in the matter of success. I say success can be achieved.

22. Though the audience be stronger in numbers, one may prevent them from their critics. Scheme so as to discover their plans and likelihood of their success.

<p align="center">C.6.(19-22)</p>

23. Rouse the audience, and learn the principle of their activity or in activity. Force the audience to reveal the potential patrons, so as to find out their vulnerable spots.

24. Carefully compare the opposing works of art with your own, so that one may know where strength is superabundant and where it is deficient. (This also applies to the artists as well)

25. Beware of dream thieves, style manipulators, and concept jackals. Strategies of deception must keep one's style secrets concealed. The vultures seek those of new successes.

26. How success may be produced for an artist out of the audience's own inspiration and creativity —that is what the masses cannot understand.

<p style="text-align:center">C.6.(23-26)</p>

27. All artists can see the inspiration and creativity whereby an artist conquers, but what none can see is the strategy out of which success is evolved.

28. Do not repeat the tactics and techniques which have gained an artist success, but let one's method be regulated by the infinite variety of circumstances.

29. Artists must learn tactics like that of the military and unto water; for water in its natural course runs away from high places and hastens downward.

30. So in art as in war, the way is to avoid what is strong and to strike what is weak.

31. Water shapes its course according to the

31(cont'd). nature of the ground over which it flows; the artist works out one's success in relation to the audience being faced.

32. Therefore, just as water retains no constant shape, so in art there are no constant conditions.

33. An artist who can modify one's tactics in relation to their audience and thereby succeed, may be called a Master Artist.

34. "The five elements (water, fire, wood, metal, earth) are not always equally predominant: The four seasons make way for each other in turn. There are short days and long: the moon has its periods of waning and waxing."

– Sun Tzu, *The Art of War*

CHAPTER SEVEN

ARTISTIC MANEUVERING

Ch. 7

1. In art, the artist receives their command from their own interpretations of the world.

2. Having collected an audience and concentrated one's artistic force, one must blend and harmonize the different elements thereof before pitching headquarters.

3. After that, comes artistic maneuvering, than which there is nothing more difficult. The difficulty of artistic maneuvering consists in turning the devious into the direct, and misfortune into gain.

4. The artist must take long and often arduous paths, even enticing their audience out of their reality, even though sometimes being in disagreement with the audience, to reach before the audience, shows mastery of the artifice of deviation.

C.7.(1-4)

5. Maneuvering with art is advantageous: with an undisciplined multitude, most certain to end in failure and destruction.

6. If one set a fully equipped exhibition in order to snatch an advantage, most likely one will be too late. On the other hand, to attach a mobile army series for the purpose involves the benefits of storage and baggage.

7. Thus, if one orders their art to exhibition, and make forced touring without halting day or night, covering double the usual distance at a stretch, doing a hundred exhibitions to wrest an advantage, the lead signature pieces will arise to become famed, celebrated, and successfully worked into the hands of patrons.

8. The stronger pieces will be in front, the jaded ones will fall behind, and on this plan only

8(cont'd). one-tenth of one's art will reach success with its audience.

9. If one travels to out maneuver the audience, one will lose the leader of a series, and only half the concept will find success.

10. If one travels shorter distances with the same art, two-thirds of the art will be successful.

11. One may take it then that an artist without baggage- exhibition is lost: without studio it is lost; without bases of supplies art is lost.

12. An artist should not enter an alliance until one is acquainted with their neighbor.

13. An artist is not fit to lead their exhibition unless one is familiar with the face of the country – it's mountains and forests, it's pitfalls and precipices, it's marshes and swamps.

14. An artist shall be unable to turn natural advantage to account unless one makes use of local patronage.

15. In art, practice dissimulation, and one will succeed.

16. Whether to concentrate or to divide one's art, must be decided by circumstances.

17. *"Let your rapidity be that of wind, Your compactness that of the forest."*

- Sun Tzu, *The Art of War*

C.7.(13-17)

18) *"In raiding and plundering be like fire, in immovability like a mountain."* – Sun Tzu, *The Art of War*

19) Let one's studio be dark and impenetrable as night, when you exhibit, fall like a thunderbolt.

20. When one plunders a venue, let the spoils be divided amongst one's advisors; when one captures a new territory, cut it up into technique based markets for overall cohesive benefit of the art and the artist.

21. *"Ponder and deliberate before you make a move."* – Sun Tzu, *The Art of War*

22. The artist will succeed who has learnt the artifice of social and intellectualized deviation. Such, maneuvering through the Art World with great caution and even greater art.

23. Art Management: on the walls, the spoken word does not carry far enough: hence the institution of gongs and drums. Nor can creative endeavors be seen clearly enough: hence the institution of banners and flags.

24. Gongs and drums, banners and flags, are means whereby the ears and eyes of the audience may be focused on one particular point.

25. The artist forming a single united body of work, it is impossible for the weakest of pieces to

25*(cont'd).* advance alone, or for the boldest to retreat into secret. There is an art to handling large masses of work.

26. In- night exhibitions, then make much use of signal-fires and drums, and in exhibiting by day, of flags and banners, as a means of influencing the ears and eyes of an audience.

27. A whole body of work may be robbed of its spirit; an artist may be robbed of their presence of mind.

28. Now an audience's spirit is keenest in the morning; by noonday it has begun to flag; and in evening their minds are bent only on returning from work.

29. A clever artist, therefore, avoids an audience when its spirit is keen, but exhibits, when it is sluggish and inclined from work. This is the art of studying moods.

30. Disciplined and calm, to await the appearance of disorder and hubbub amongst the audience: This is the art of retaining self-possession.

31. To be near the concept while the audience is still far from it, to wait at ease while the audience is toiling and struggling with the work, to be well-fed with knowledge while the audience is famished- this is the art of husbanding one's strength.

32. To refrain from intercepting an enemy whose banners are in perfect order, to refrain from attacking an artist drawn up in calm and confident array: this is the art of studying circumstances.

34. Do not pursue an audience who simulates flight; do not exhibit other artist's work whose temper is keen.

35. Do not follow bait offered by audience or critic, whether it be positive or negative… Do always lend an ear to a previous patron or collector.

36. When one surrounds an audience, leave an outlet free. Do not press a potential patron hard.

C.7.(32-36)

37. Such is the warfare of art.

CHAPTER EIGHT

VARIATIONS

of

ART

TACTICS

C.8.

1. In Art, the artist receives command from the creative sovereignty in abide with the current, collect one's work and concentrate one's creative energy.

2. When in a difficult venue, do not encamp. In venues where high society intersects, join hands with one's allies. Linger in creatively isolated situations. In hemmed-in venues, one must resort to strategy. In desperate venues, an artist must produce.

3. There are paths which must be followed, audiences which must be attacked, towns which must be besieged by creativity, positions of creative control which must be contested, commands of the Art World which must not be obeyed.

4. The artist who thoroughly understands the advantages that accompany variation of techniques, knows how to handle one's audience.

5. The artist who doesn't understand various techniques, may be well acquainted with the configuration of their own style, yet one will not be able to turn knowledge to expanding creative accounts.

6. So, the soldier of art who is unversed in *The War of Art* of varying one's strategies, even though acquainted with Five Advantages, will fail to create situations best for viewing art.

7. Hence in the most creative of an artist's plans, consideration of advantages (technique based

7 *(cont'd)*. superiorities) and of disadvantage (limitations)

8. If one's expectation of advantage be tempered in this way, an artist may succeed in accomplishing the essential part of their concept.

9. If, on the other hand, in the midst of being one with the current an artist must always be ready to seize the advantage, so that one may interlace one's self with fortune.

10. Reduce the hostile critics, avoid inflicting damage on them; and make for them by producing, and keep the audience constantly engaged; hold out specious allurements, and make them work to any given point.

$$C.8.(7-10)$$

11. *The War of Art* teaches one to rely not on the likelihood of the audience coming, but on an artist's own readiness to receive them; not on the chance the audience is hostile, but rather on the strength of one's techniques that makes one's artwork unassailable.

12. There are five dangerous faults which may affect an artist:

(1) Recklessness, which leads to destruction.

(2) Cowardice, which leads to moral neglect.

(3) A hasty temper, which can be provoked by critic.

(4) A delicacy of entitlement which is sensitive to ego.

(5) Over exposure for one's art, which exposes the artist to worry and trouble.

13. These are the five besetting sins of an artist, ruinous to the production of art and the longevity of the artist's professional career.

14. When art is mocked and its artist a failure, the cause will surely be found among these five dangerous faults. Let this be a subject of meditation.

CHAPTER NINE

ART

on the

MARCH

C. 9.

1. We come now to the question of encamping the, and observing signs of the audience. Pass quickly over mountains, and keep in the neighborhoods of cities.

2. Set up studio in high places, facing the sun. Do not climb heights in order to exhibit. So much for mountain exhibitions.

3. *"After crossing rivers, you should far away from it."* – Sun Tzu, *The Art of War*

4. When an invading audience crosses a river in its onward march, do not advance to meet them mid-stream. It will be best to let half the art get across to the audience, and then deliver the concept.

5. If anxious to exhibit, one should not go to meet the audience near a river which one has to cross.

6. Motivate one's craft higher up than that of the audience's expectations, and facing the sun. Do not move against the current to meet the audience. So much for a river exhibition.

7. In crossing a bitter audience, one's sole concern should be to get over them quickly, without any delay?

8. If forced to exhibit to a bitter audience, an artist should have water and grass near, and get one's back to a clump of trees. So much for exhibitions in bitter audiences.

C.9.(5-8)

9. In a dry audience, level exhibition, take up an easily accessible technique with rising concept from the right and the rear, so that the audience may be in front and safely lie behind. So much for exhibitions in flat country.

10. These are the four useful branches of audience dynamic which will enable an artist to vanquish fear of the four archetypes of audience.

11. All art prefer to be exhibited high ground to low ground and well lit places to dark.

12. If one is careful of the art, and camp on hard ground, the work will be free from damage of every kind, and this is key to success.

13. When an artist encounters a drought or a bank, occupy the sunny side, with drought behind. Thus, an artist is forced to act for the benefit of one's art and utilize the natural advantages at one's disposal.

14. When, in circumstance of heavy rain occurs in city exhibitions, a social river which one wishes to cross is swollen and flecked with pollution, one must wait for it to subside.

15. Venues in which there are precipitous career cliffs with torrents running between, deep natural lows, confined spaces, tangled manifests, and social abysses, should be left with all possible haste and not approached. Better yet, avoided.

16. While artists keep away from such places, artist should get the audience to approach them; while an artist has grounding, one should let the audience have it in the rear.

17. If the neighborhood of your studio there should be any hilly country, ponds surrounded by aquatic grass, hollow basins filled with reeds, or woods with thick undergrowth, they must be carefully routed and searched for; these are the places where studios of art or inspirational places are likely to be.

18. When the audience is close at hand and remain quiet, they are relying on the natural strength of their position.

19. When an artist is aloof and tries to provoke the audience, one is anxious for the other side to advance.

20. If the venue is easily accessible, one is tendering bait.

21. Movement of amongst the press of media shows that the audience is advancing. The appearance of a number of screens in the midst of static means that the media wants to take notice.

22. The rising of birds in their flight is sign of a media ambuscade. Startled beasts indicate that a sudden attack is coming.

23. When there is noise rising to the high columns, it is a sign of the chariots of failure advancing; when the dust is low, but spread over a wide area, it betokens the approach of artists, patrons, and success. When it branches out in different directions, it shows that parties have dispersed to gather information. A few clouds of dust forming signify that the audience is fully involved in the exhibition.

24. Humble words and increased preparations are signs that an artist is about to advance. Violent language and driving forward as if on a path of success are signs that one will utterly fail.

25. When the stretch chariots come out first and take position on the wings, it is a sign that the audience is of top tier finances.

C.9.(23-25)

26. Contractual proposals unaccompanied by sworn covenant indicates dishonest intentions and a plot.

27. When there is much running about and the exhibit is on display, and the audience falls into rank, it means that the critical moment has arrived.

28. When patrons are seen advancing and retreating, it is lure.

29. When the audience stand leaning on their spears, they are faint from want of food.

30. If those who are sent to draw water begin

30 *(cont'd)*. by drinking themselves, the art is suffering from thirst of art.

31. If the audience sees a financial advantage to be gained and mistakes no effort to secure it, the patrons have over exhausted their reach.

32. *"If birds gather on any spot, it is unoccupied. Clamor by night betokens nervousness."* – Sun Tzu, *The Art of War*

33. If there is disturbance in the exhibition, the artist's authority is weak. If the banners and flags are shifted about, disorganization is afoot.

34. When an artist feeds its horses with grain

34*(cont'd)*. and kills its cattle for food, and when the artists do not hang their cooking-pots over the camp-fires, showing that they will not return to bed, but instead their studios, one may know that they are determined for success or to death.

35. The sight of patrons whispering together in small knots or speaking in subdued tones points to affection amongst the audience.

36. Too frequent rewards signify that the audience is at the end of their resources; too many punishments betray a condition of dire distress.

37. To begin by bluster, but afterwards to take fright at the audience's numbers, shows supreme

37 (cont'd). lack of intelligence.

38. When critics are sent with compliments in their mouths, it is a sign that the Art World wishes a truce.

39. If the Art World critics march up angrily and remain facing for a long time without joining the dialog or leaving, the situation is one that demands great vigilance and circumspection. (introspection)

40. If the art is no more in number than the audience, that is amply sufficient; it only means that no solo exhibition can be made. What one can do is simply to concentrate all available strength. Keep a close watch on the audience,

40*(cont'd).* and obtain reinforcements.

41. The artist who exercises no forethought but makes light of one's contemporaries is sure to be surpassed by them.

42. If an audience is conceptually punished before they have grown attached to the art, they will not prove submissive; and, unless submissive, they will be practically useless. If, when the audience has become attached to the art, conceptual rewards are not reinforced, they will still be useless.

43. Therefore an audience must be treated in first instance with humanity, but kept captive attention by means of creative discipline. This is a certain road for success.

<div style="text-align: center;">C.9.(40-43)</div>

44. If in training an artist's techniques are habitually enforced, the art will be well-disciplined; if not, its discipline will be sloppy.

45. If an artist shows confidence in their work, but always insists on one's technique being researched and developed, the gain will be exponential.

CHAPTER TEN

DIALOGUES Of TERRAIN

1. One may distinguish six kinds of dialogs of terrain, to succeed in *The War of Art*:

(1) Accessible Dialog;

(2) Entangling Dialog;

(3) Temporizing Dialog;

(4) Narrow Dialog;

(5) Precipitous Heights;

(6) Positions of a Great Distance;

2. Conversation which can be freely traversed by both sides is called ACCESSIBLE DIALOG.

3. With regard to dialog of this nature, be fore the audience in occupying the raised and sunny spots, and carefully guard one's line of intellect.

C.10.(1-3)

4. Dialog which can be abandoned but is hard to re-occupy is called ENTANGLING DIALOG.

5. From a dialog of this sort, if the audience is unprepared, one may press forth and defat them. But if the audience is prepared for the exhibition, and one fails to defeat the audience in owning the atmosphere, then, return being impossible, disaster will ensue.

6. When the position is such that neither side will gain by making the first move, it is called TEMPORIZING DIALOG.

7. In a conversation of this sort, even though the audience should offer an attractive bait, it will be advised not to stir forth, but rather to retreat,

7 *(cont'd)*. thus enticing the audience in one's turn; then; when part of the audience comes out, one may deliver attack with advantage. It will be advisable not to stir forth, but rather to retreat, thus enticing the audience in turn; when part of the audience has come out, one may deliver the exhibition with advantage.

8. With regard to NARROW DIALOG, if one can occupy them first, let them gather in mass and await the advent of the audience.

9. Should the audience forestall one in an occupying dialog, do not go after them if the dialog is fully garrisoned, but only if it is weakly capitalized.

10. With regard to PRECIPITOUS HEIGHTS, if one is beforehand with the audience, one should occupy the raised and sunny spots, and there wait for dialog.

11. If the audience has occupied the exhibition before the artist, follow them and engage with conversation.

12. If an artist is at great ideological distance from the audience, and the intellect of the two is equal, it is easy to provoke dialog, the conversation will be advantageous.

13. These six are the principles connected with Earth. The artist who has attained a responsible awareness must be careful to study them.

<center>C.10.(10-13)</center>

14. Now an audience is exposed to six several calamities, not arising from natural causes, but from faults for which the artist is responsible. These are:

(1) Flight;

(2) Insubordination;

(3) Collapse;

(4) Ruin;

(5) Disorganization;

(6) Rout

15. Other conditions being equal, if one concept is hurled against another ten times it's size, the result will be FLIGHT of the former.

16. When the general audience is too strong and the art too weak, the result is INSUBORDINATION. When the art is too strong and the general audience too weak, the result is COLLAPSE.

17. When the highest cruitics are angry and insubordinate, and on experiencing the art give dialog of their own account from a feeling of resentment, before the artist can tell whether or not in a dialog of aggression, the result is RUIN.

18. When the artist is weak and without authority; when the techniques and concepts are not clear and distinct; when there are no back stories and history to the art, and the exhibition/presentation is formed in a slovenly haphazard manner, the result is utter DISORGANIZATION.

<div style="text-align: center;">C.10.(16-18)</div>

19. When an artist, unable to estimate the audience's strength, allows an inferior audience to engage a more conceptual work, or hurl a weak exhibition against a powerful audience, and neglects to place signature pieces in the front, the result might be a ROUT.

20. These are the six ways of courting failure, which must be carefully noted by the artist who has attained a responsible awareness.

21. The natural current of the Earth is the artist's best ally; but a power of estimating the audience, of controlling the currents of success, and of shrewdly calculating difficulties, dangers and dialog, constitutes the test of a great artist.

C.10.(19-21)

22. One who knows these things, and on exhibition puts one's knowledge into practice, will be successful. One who knows not, nor practices them, will surely fail.

23. If an exhibition is sure to result in success, then an artist must exhibit, even though the Art World forbid it; if exhibiting will not result in success, then one must not exhibit even at the Art World's bidding.

24. The artist who advances without coveting fame and fails without fearing disgrace, whose only thought is to produce art and exhibit mastery of craft, is a jewel of the world.

25. Regard one's art as one's children, and they

25*(cont'd)*. and they will follow an artist into the deepest valleys; look upon them as beloved kin, and they will stand by you even unto death. A monument to the legacy of creativity.

26. If, however, one is indulgent, but unable to display mastery of technique; kind-hearted, but unable to promote and inspire creativity on command; and incapable, moreover, of quelling the disorder of the world; then one's art must be likened to spoilt children; they are useless for any practical purpose, aesthetic or conceptually.

27. If an artist knows that its own art is in a condition to exhibit, but is unaware that the audience is not open for an exhibition, one has gone only half way towards success.

<div style="text-align: center;">C.10.(25-27)</div>

28. If an artist knows the audience is open for art, but is unaware that one's own art is not in a condition to exhibit, one has gone only halfway towards success.

29. If an artist knows that the audience is open for an exhibit, and also know that one's art is at a standard to exhibit, but are unaware the nature of the venue makes for an impractical atmosphere. One still has only gone halfway to success.

30. Hence the experienced artist, once in motion, is never bewildered; once one has the comforts of camp, one is never at a loss.

31. Hence the saying:

 C.10.(28-31)

31 *(cont'd).* "If you know the audience and know your art, your success will not stand in doubt; if you know Heaven and know earth, you may make your success complete."

CHAPTER ELEVEN

The 9 Situations

C.11

1. *The War of Art* recognizes nine varieties of artistic ground:

(1) Dispersive Artistic Ground;

(2) Facile Artistic Ground;

(3) Contentious Artistic Ground;

(4) Open Artistic Ground

(5) Ground of Intersecting Highways

(6) Serious Artistic Ground;

(7) Difficult Artistic Ground;

(8) Hemmed-In Artistic Ground;

(9) Desperate Artistic Ground;

2. When an artist is exhibiting in one's own

2*(cont'd)*. territory, it is

DISPERSIVE ARTISTIC GROUND.

3. When an artist has penetrated into hostile territory, but to no great distance, it is

FACILE ARTISTIC GROUND.

4. Ground, the possession of which imports great advantage to either artist, patron , or both, **CONTENTIOUS ARTISTIC GROUND.**

5. Ground on which each side has liberty of movement is **OPEN ARTISTIC GROUND.**

6. Ground which forms the key to three

6*(cont'd)*. contiguous general public audiences, so that the artist occupies it first has most of the venues on command, is a

GROUND of INTERSECTING HIGHWAYS.

7. When an artist has penetrated into the heart of a hostile audience, leaving a number of fortified cities in their rear, it is

SERIOUS ARTISTIC GROUND.

8. Mountain forests, rugged steeps, marshes and fens – all country audiences are hard tor traverse and require trade: this is

DIFFICULT ARTISTIC GROUND.

9. Ground which is reached through narrow

9*(cont'd)*. narrow dialog, and from which one can only retire by tortuous paths, so that a small number of critics would to suffice to crush a large body of work: this is

HEMMED-IN ARTISTIC GROUND.

10. Ground on which an artist can only be saved from failure by exhibiting without delay, is DESPERATE ARTISTIC GROUND.

11. DISPERSIVE ARTISTIC GROUND, therefore, exhibit not. FACILE ARTISTIC GROUND push to exhibit. CONTENTIOUS ARTISTIC GROUND, be conservative in one's measures.

12. OPEN ARTISTIC GROUND, do not try

12*(cont'd)* and block the dialog. On the GROUND of INTERSECTING HIGHWAYS, join hands with one's allies.

13. SERIOUS ARTISTIC GROUND, gather in plunder. DIFFICULT ARTISTIC GROUND, keep steadily on the exhibit.

14. HEMMED-IN ARTISTIC GROUND, resort to "strategies".

DESPERATE ARTISTIC GROUND, EXHIBIT.

15. Those who were called skillful art critics of old knew how to drive a wedge between the artists front and rear skill levels; to prevent co-operation between larger known artists and

15(cont'd). smaller divisions; to hinder the good artists from inspiring the bad, the artists from evolving their art.

16. When the critics are united, an artist will manage to keep them in order.

17. When is to advantage, move forward; when otherwise, remain centered.

18. If asked how to cope with hosting a great exhibition in orderly array and on the point of exhibiting to the audience, I should say," Begin by seizing something which your audience holds dear, then they will be amenable to the art. (mine is color & texture).

19. Rapidity is the essence of art. Take advantage of the audience's unreadiness, make one's way by unexpected routes, and exhibit in unguarded spots.

20. The following are the principles to be observed by an invading artist: The further one penetrates into that community, the greater will be the solidarity of the work produced during this time, and thus the critics will not prevail against the art or the artist.

21. Set up headquarters in fertile country in order to supply and produce art.

22. Carefully study the well-being and awareness of one's self, the art, and do not overtax either.

22*(cont'd)*. Concentrate the energy on the art and focus one's strength. Keep the art continually on the move, and devise unfathomable plans.

23. Exhibit one's art into positions whence there is no escape, and art will prefer success to failure. If it faces success, there is nothing it may not achieve. Critics and patrons alike will put forth their utmost strength.

24. A truly great artist when in desperate straits loses sense of fear. If there is no place of refuge, a truly great artist will stand firm. If they lead a stubborn life. If there is no help for it, an artist will create ruthlessly and without discretion leading to success.

<div style="text-align:center">C.11.(22-24)</div>

25. Thus without waiting to be grandfathered in, the art will be on attack; without needing an exhibition, it will be ready; without restrictions, critics will be faithful; without giving orders, the audience can be trusted.

26. Prohibit the taking of omens, and do away with superstitious doubts. Then, until death itself comes, no calamity need be feared.

27. If an artist is not overburden with money, it is not because they have a distaste for riches and fame; if their careers are not unduly long, it is not because they are disinclined to longevity.

28. On the day of an exhibition, the art may make one want to cry, bury their head in their

28*(cont'd)*. hands, and some just may want to crawl into a burial tomb beneath Earth. But let the art once be brought on exhibit to the audience, and the art will display the courage of the artist.

29. The skillful artist may be likened to the SHUAU-JAN. Now the SHUAI-JAN is a snake that is found in the Ch'ang mountains. Strike at its head, and you will be attacked by its tail; strike at its tail, and you will be attacked by head and tail both.

30. Asked if an artist can be made to imitate the SHUAI-JAN, I should answer, Yes. For the artist and the art critic are enemies; yet if they are crossing a river in the same boat and are caught by a storm, they will come to each other's

30*(cont'd)*. assistance just as the left hand helps the right.

31. Hence it is not enough to put one's trust in the art, and the accolades of the audience.

32. The principle on which to manage an artist's production is to set up one standard of courage which all pieces must reach.

33. How to make the best of both strong and weak - that is a question involving the use of creativity.

34. Thus the skillful artist creates one's art just as though one were creating a single brush

34*(cont'd)*. stroke, willy-nilly, by hand.

35. It is the business of an artist to be stealth and thus ensure secrecy; upright and just, and thus maintain the order.

36. One must be able to mystify the audience and critics by false reports and appearances, and thus keep them in total ignorance.

37. By altering arrangements and changing plans, an artist keeps the audience without definite knowledge. By shifting techniques and taking circuitous routes of logic, one prevents the audience anticipating the purpose of the art.

38. At the critical moment, the art acts as leader of the audience likened to one has climbed up a height and then kicks away the ladder behind them. Great art carries the audience into hostile territories of concept, creative intrigue. Technique, and always challenging, before it shows its hand.

39. An artist burns bridges and breaks cooking-pots; like a shepherd driving a flock of sheep, driving the art this way and that, and nothing knows whither one is creating or failing.

40. To muster the audience and bring them into awareness: - this may be termed the business of the artist.

41. The different measures suited to the Nine Situations of Artistic Ground; the expediency of aggressive or defensive tactics; and the fundamental laws of human nature: these are things that must most certainly be studied.

42. When exhibiting in hostile territories, the general principle is, that deep saturation of localized markets bring cohesion with the community; penetrating but in a short way means dispersion amongst the community.

43. When an artist leaves their own country behind, and exhibits art across neighboring and distant territories, one finds themselves on critical ground. When there are means of communication on all four sides, the Ground is that of Intersecting Highways.

<center>C.11.(41-43)</center>

44. When an artist penetrates deeply into a territory, it is Serious Artistic Ground. When one penetrates but a little way, it is Facile Artistic Ground.

45. When one has the audience's stronghold on your tail, and narrow passage in front, it is Hemmed-In Artistic Ground. When there is no place creative production and refuge at all, it is Desperate Artistic Ground.

46. Therefore, on Dispersive Artistic Ground, I would inspire my art with unity of purpose. On Facile Artistic Ground, I would see that there is close connection between all parts of my art and process.

47. On Contentious Artistic Ground I would hurry up my rear.

48. On Open Artistic Ground I would a keep vigilant eye on my defenses. On Ground of Intersecting Highways, I would consolidate my alliances, patrons, and critics.

49. On Serious Artistic Ground, I would try to ensure a continuous stream of supplies and work space. On Difficult Artistic Ground, I would keep pushing along the path of production.

50. On Hemmed-In Artistic Ground, I would block any way of failure). On Desperate Artistic Ground, I would focus my art on the successes of technique in hopes of avoiding failure.

C.11.(47-50)

51. For it is the artist's disposition to offer obstinate resistance when surrounded, to exhibit harder creating more art when one cannot help themselves, and disobey the Art World promptly when one's work has fallen into the dangers of over-generalized categorization, censorship, and elitism.

52. An artist cannot enter into an alliance with neighboring venues until one is acquainted with their designs, aesthetics, and atmosphere. An artist is not fit to lead their art on the exhibit unless one is familiar with the face of the country – it's mountains and forests, it's pitfalls and precipices, it's marshes and swamps. An artist shall be unable to turn natural advantages to account unless one make use of local guides.

C.11.(51-52)

53. To be ignored of any e of the following four or five principles does not befit a warlike artist.

54. When a warlike artist exhibits at a powerful venue, his generalship shows itself in preventing the concentration of audience's force. An artist overawes the critics, and their allies are prevented from joining against the art.

55. Hence, the artist does not strive to ally with all and sundry, nor does an artist foster the influence of the Art World. An artist carries out their own secret designs, keeping antagonists and dream thieves in awe. Thus, be able to capture cities and overthrow belief systems of retired times.

C.11.(53-55)

56. Bestow production without regard to the rule, acquire supplies without regard to previous arrangements; and one will be able to handle an entire exhibition of art as though one had to do but a single painting.

57. Confront patrons with the concept itself; never let them know the designs. When the outlook is bright, bring it before their eyes; but tell them nothing when the situation is gloomy.

58. Place one's art in deadly peril, and it will survive; plunge it into desperate straits, and it will come off in safety.

59. For it is precisely when art has fallen into harm's way that is capable of striking blow

59*(cont'd).* towards grand awareness.

60. Success in *The War of Art* is gained by carefully accommodating the audience to the artist's purpose.

61. By persistently hanging on the audience's flank of creative spectrum, an artist shall succeed in the long run of engaging the audience's interest and patronage.

62. This is called the ability to accomplish a thing by sheer cunning.

63. On the day that an artist take up an exhibition, open all frontier outlets, destroy

63*(cont'd)*. the official tallies, and allow the passage of all emissaries.

64. Be stern in negotiations, but heed strong personal council and legal advisors- so that one may control the situation.

65. If a patron leaves a door open, an artist must rush in.

66. Forestall a patron by assimilating art with what they hold dear, and subtly contrive to time their departure with a scheduled arrival on the ground.

67. Walk in the path defined by current, and

C.11.(63-67)

67 *(cont'd)*. accommodate one's art to the audience until one can exhibit with a decisive venue.

68. At first, then, exhibit coyness of a maiden, until the audience gives one an opening; afterwards emulate the rapidity of a running hare.

CHAPTER TWELVE

The Attack

By

Fire Of Promotion

&

Getting Up.

C. 12.

1. There are five ways of attacking with fire, quality art. The first is to wall burn the audience in their homes; the second is to wall burn stores; the third is to wall burn commuting audiences subject to mandatory high traffic intersections and thorough fairs; the fourth is to wall burn/page burn patron arsenals, magazines, and media outlets; the fifth is to hurl dropping auditory art fire promotions amongst the soon-to-be audience and future patrons.

2. In order to carry out an exhibition, one must have means available. The material for raising wall fire should always be kept in readiness.

3. There is proper season for making attacks with fire, and special days for exhibiting.

<center>C.12.(1-3)</center>

4. The proper season is when the weather is very dry; the special days are those when the moon is of fullness.

5. In attacking with art fire, one should be prepared to meet five possible developments.

6(1). When art fire breaks in audiences of personal residency, respond at once with an inviting dialog, subtle with exhibit, but most certain.

7(2). If there is an outbreak of art wall fire, but the audience remain quiet, bide one's time and do not exhibit.

8(3). When flames of interest have reached it's

8(3) *cont'd*]. height, follow it up with an exhibit, if that is practical; if not, stay humble.

9(4). If it is possible to make an exhibition with fire from without fire, do not wait for it to break out within, but deliver the art exhibition at a favorable moment.

10(5). When an artist starts an art fire, be to windward of it. Do not exhibit from leeward.

11. *"A wind that rises in the daytime lasts long, but a night breeze soon falls."* – Sun Tzu, *The Art of War*

12. In every exhibition, the five developments

12*(cont'd)*. connected with fire art must be known, the movements of the stars calculated, and a watch kept for the proper days.

13. Hence those who use art fire as an aid to exhibit show intelligence; those who do not use alcohol as an aid to attack gain accession of strength of production.

14. By means of spirits, a patron may be intercepted, but not guaranteed of commitment to the art.

15. Unhappy is the fate of one who tries to win art world battles and succeed in exhibitions without cultivating the spirit of enterprise; is a waste of time, general stagnation, and failure.

C.12.(12-15)

16. Hence the saying: The enlightened artist lays one's plans well ahead and coded; the great artist cultivates one's resources.

17. Move not unless one sees an advantage; use not one's art unless the position is critical.

18. No artist should put art into the field merely to gratify one's own ego; no artist should exhibit out of spite.

19. It is always an artist's advantage, make a forward move; if not, stay where one is or failure is inevitable.

20. Anger and frustration may in time change to

20*(cont'd)*. peace and motivation; vexation, may be succeeded by content and destiny.

21. But the Art World that has once been destroyed can never come again into being; nor can the dead ever be brought back to life.

22. Hence the enlightened artist is heedful, and the great artist weighs caution against ambitions of art. This is the way to keep an Art World at peace and the art intact.

CHAPTER THIRTEEN

BEWARE

Of

DREAM

THIEVES

C. 13.

1. Producing a host of a hundred thousand works of art and marching exhibiting them great distances entails loss on production and a drain on the resources of an artist. The daily expenditure will amount to a thousand ounces of silver. There will be commotion at home and abroad, and an artist could drop down of creative, physical, mental, and emotional exhaustion on the highways. As many as seven hundred thousand families cold be impeded by one's art.

2. Hostile artists may face each other for years, striving for success which can be decided in a single day. This being so, to remain in ignorance of other artists situations simply because one grudges the outlays of a hundred ounces of silver in honors and emoluments is the height of humanity.

C.13.(1-2)

3. One who acts thus is no leader amongst artists, no present help to *The War of Art*, no master of success.

4. Thus, what enables art and masterful artist to strike and conquer, and achieve things beyond the reach of ordinary men, is FOREKNOWLEDGE.

5. *"Now this foreknowledge cannot be elicited from spirits; it cannot be obtained inductively from experience, nor by any deductive calculation."* – Sun Tzu, *The Art of War*

6. Knowledge of the audience's disposition can only be obtained from other participants.

7. Hence the use of artists, of whom there are

7 *(cont'd)*. five classes: (1) Local Artists; (2) Inward Artists; (3) Converted Artists; (4) Doomed Artists; (5) Surviving Artists.

8, When these five kinds of artists are all at work, none can discover the secret system. This is called "divine manipulation of the brushes." It is art's most precious faculty.

9. Having LOCAL ARTISTS means employing the services of the creative inhabitants of said district.

10. Having INWARD ARTISTS, making use of art stars of the Art World.

11. Having CONVERTED ARTISTS, getting hold of the audience and using their resources for the purposes of art.

12. Having DOOMED ARTISTS, doing certain things openly for purposes of deception, and allowing artists and critics know of them and report the art back to the audience.

13. SURVIVING ARTISTS, finally, are those who create art news in the world.

14. Hence it is that which none in the world will find more intimate to be maintained than with the artists. None should be more liberally rewarded. In no other pursuit should greater collections be preserved.

<div style="text-align: center;">C.13.(11-14)</div>

15. Artists cannot be usefully employed without certain intuitive sagacity (wisdom).

16. They cannot be managed properly without benevolence and straightforwardness.

17. Without subtle ingenuity of the mind, one cannot make certain of the truth of their artwork from their own accounts.

18. Be subtle! Be Subtle! And use art for every aspect of business.

19. If a secret piece of new technique is divulged by an artist before the time is ripe, the innovation may be put to death by the man whom the secret

19*(cont'd)*. was told.

20. Whether the object be to crush an audience, to storm a city, or stylistically and through sheer production output assassinate an artist's monopoly, it is always necessary to begin by finding out the names of the attendants, the critics, and door-keepers and sentries of the Art World in command. Artists must be commissioned to ascertain these.

21. Artists who have come to spy onone must be sought out, tempted with bribes, led away and comfortably housed. Thus they will become CONVERTED ARTISTS and available for mentorship.

C.13.(19-21)

22. It is through the information brought by the Converted Artist that one is able to inspire Local and Inward Artists.

23. It is only to this information, again, that one can cause the Doomed Artist to carry false tidings to the audience.

24. Lastly, it is by this information that the Surviving Artist can be used on appointed occasions.

25. The end and aim of artists in all it's five varieties is knowledge, awareness, and enlightenment of the audience; and this knowledge can only be derived, in the first instance, from the Converted Artist. Hence it is

25*(cont'd)*. essential that the Converted Artist be treated with the utmost liberality.

26. *"Of old, the rise of the Yin dynasty was due to I Chic who had served under the Hsia. Likewise, the rise of the Chou dynasty was due to Lu Ya who had served under the Yin."* - Sun Tzu, *The Art of War*

27. Hence it is only the enlightened and wisest of artists who will inspire the highest of creativity and knowledge of the audience for purposes of art thereby achieving great success...

ARTISTS are a most precious and most important element in this war, because on US depends the existence of art, as it weighs on the Failure & Success of EVERY ARTIST...

THE WAR OF ART – The Urban Monk 2014

www.ingramcontent.com/pod-product-compliance
Lightning Source LLC
Chambersburg PA
CBHW051716170526
45167CB00002B/684